Coloring Book

CIRCUS

Copyright ©Maryna Salagub

First Edition

All rights reserved. No part of this book may be reproduced in any form or by any means, electronic or mechanical, including protocopying, recording, or any information storage and retrieval system, without written permission.

Distributed by : CreateSpace

ISBN-13: 978-1539136996

ISBN-10: 153913699X

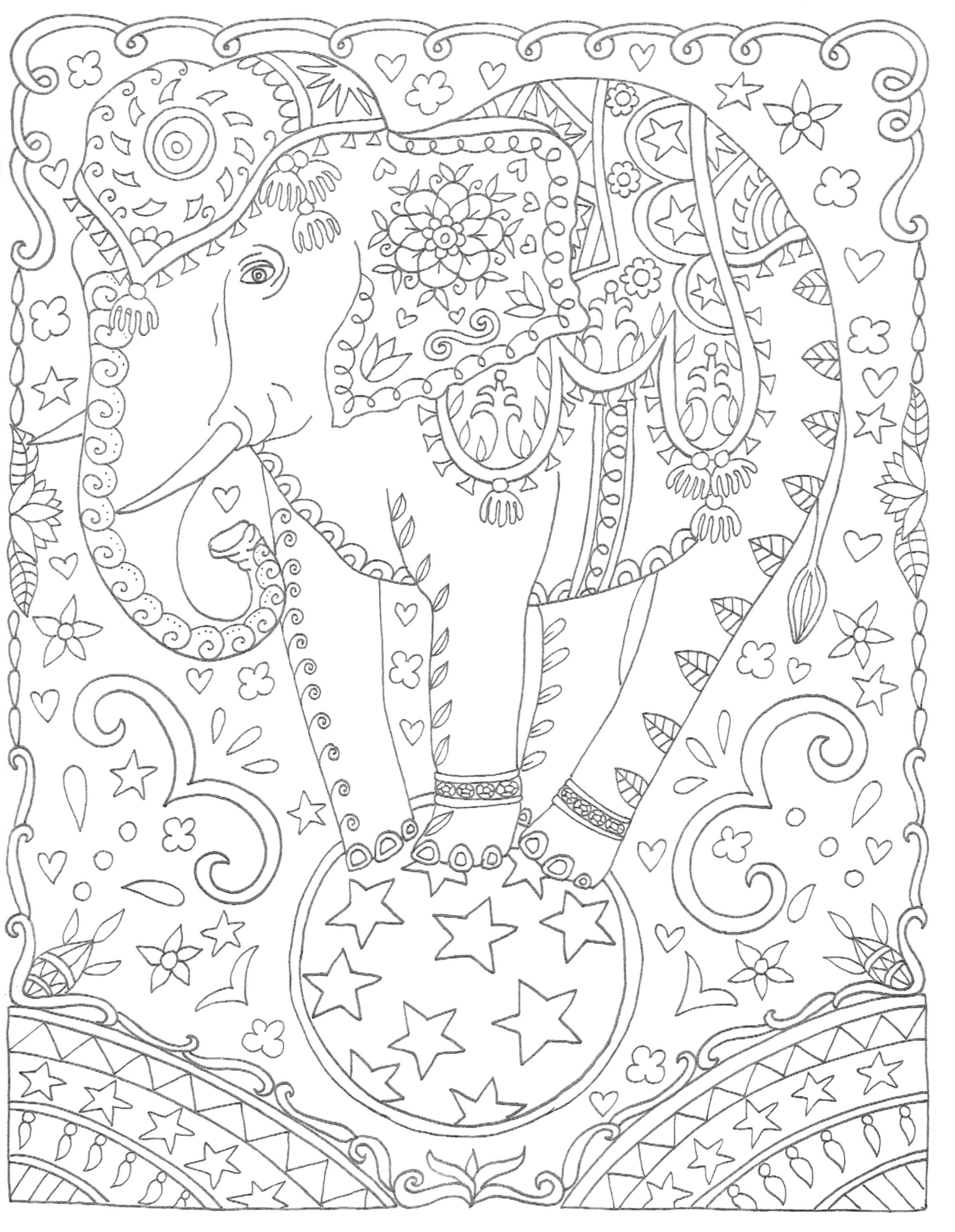

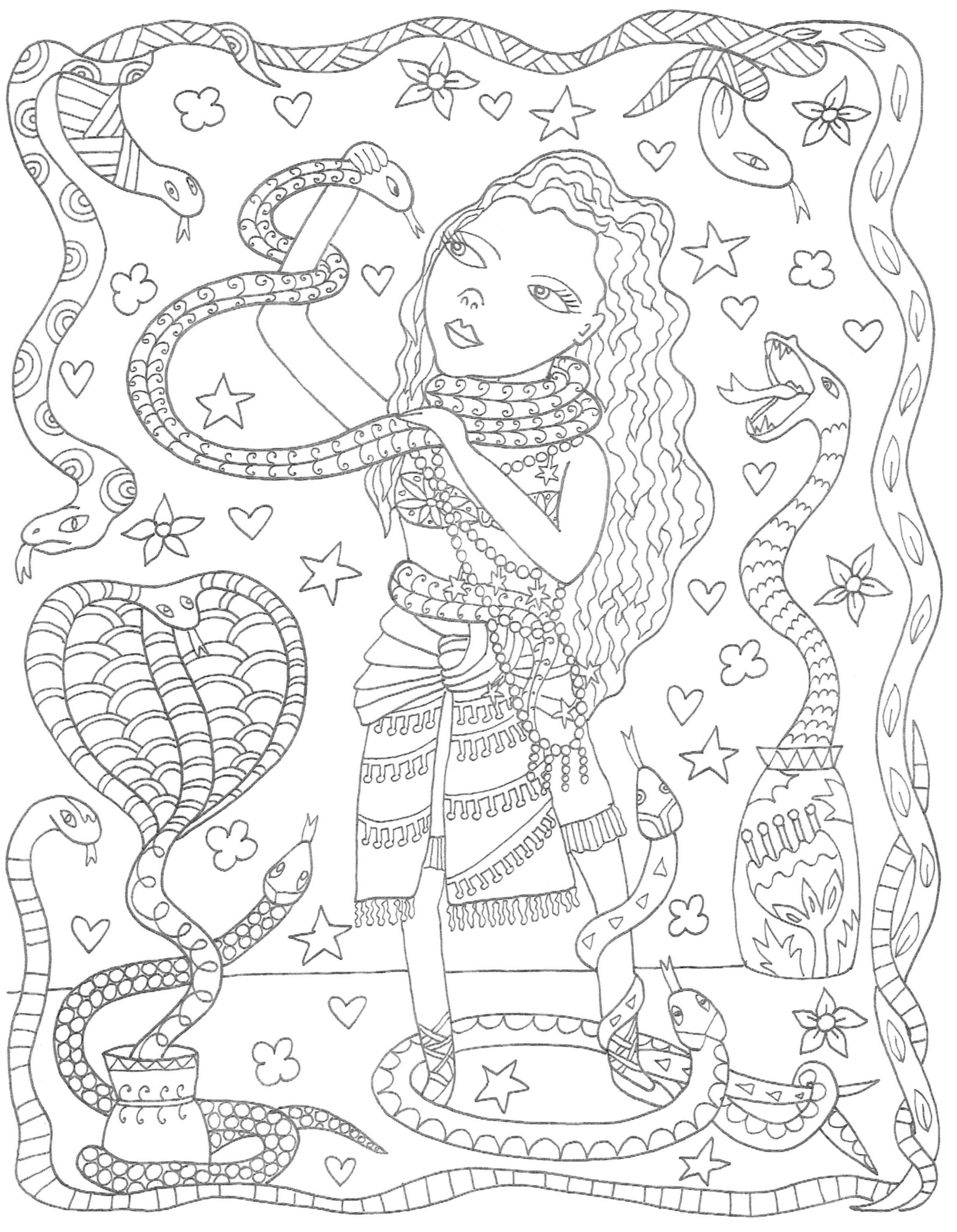

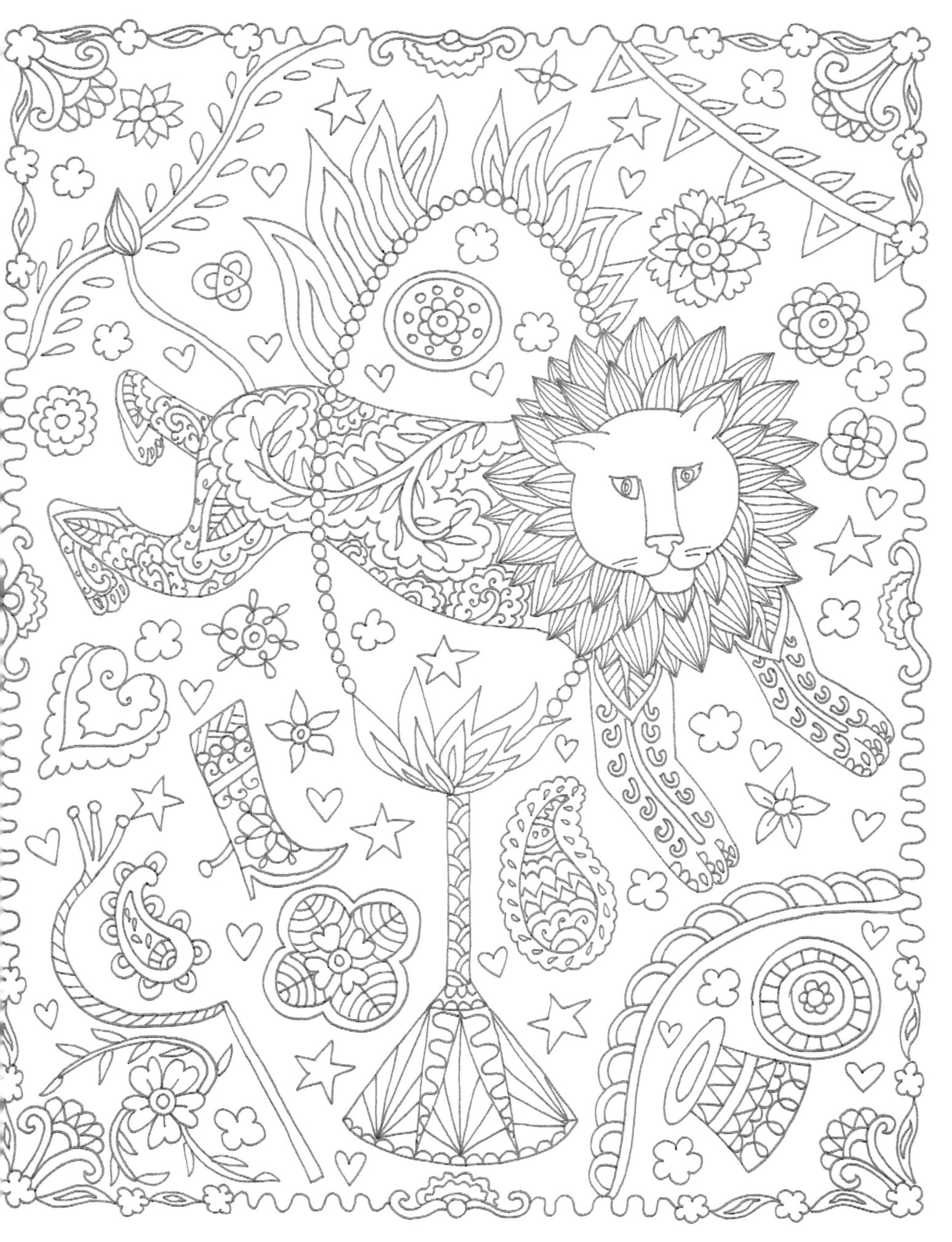

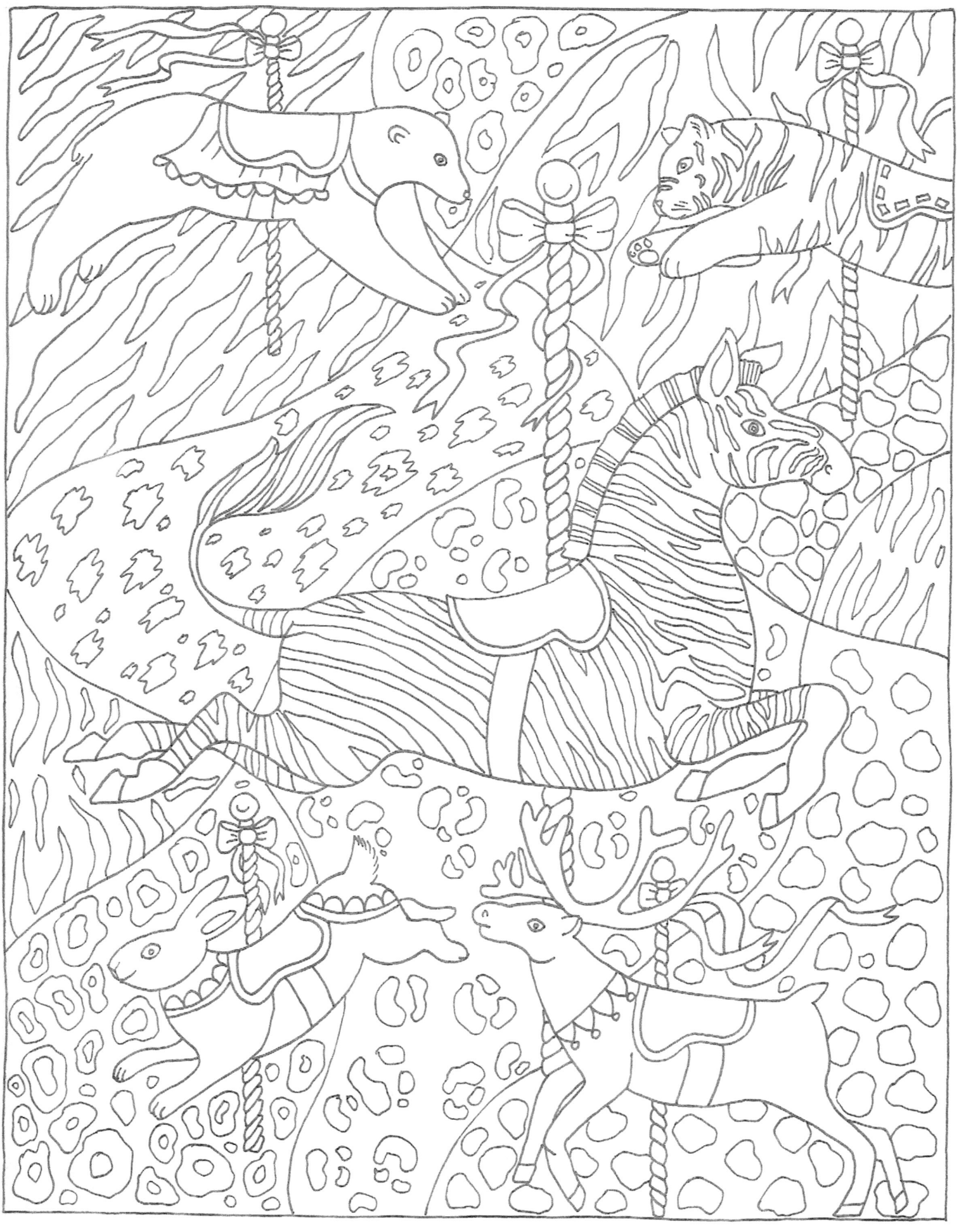

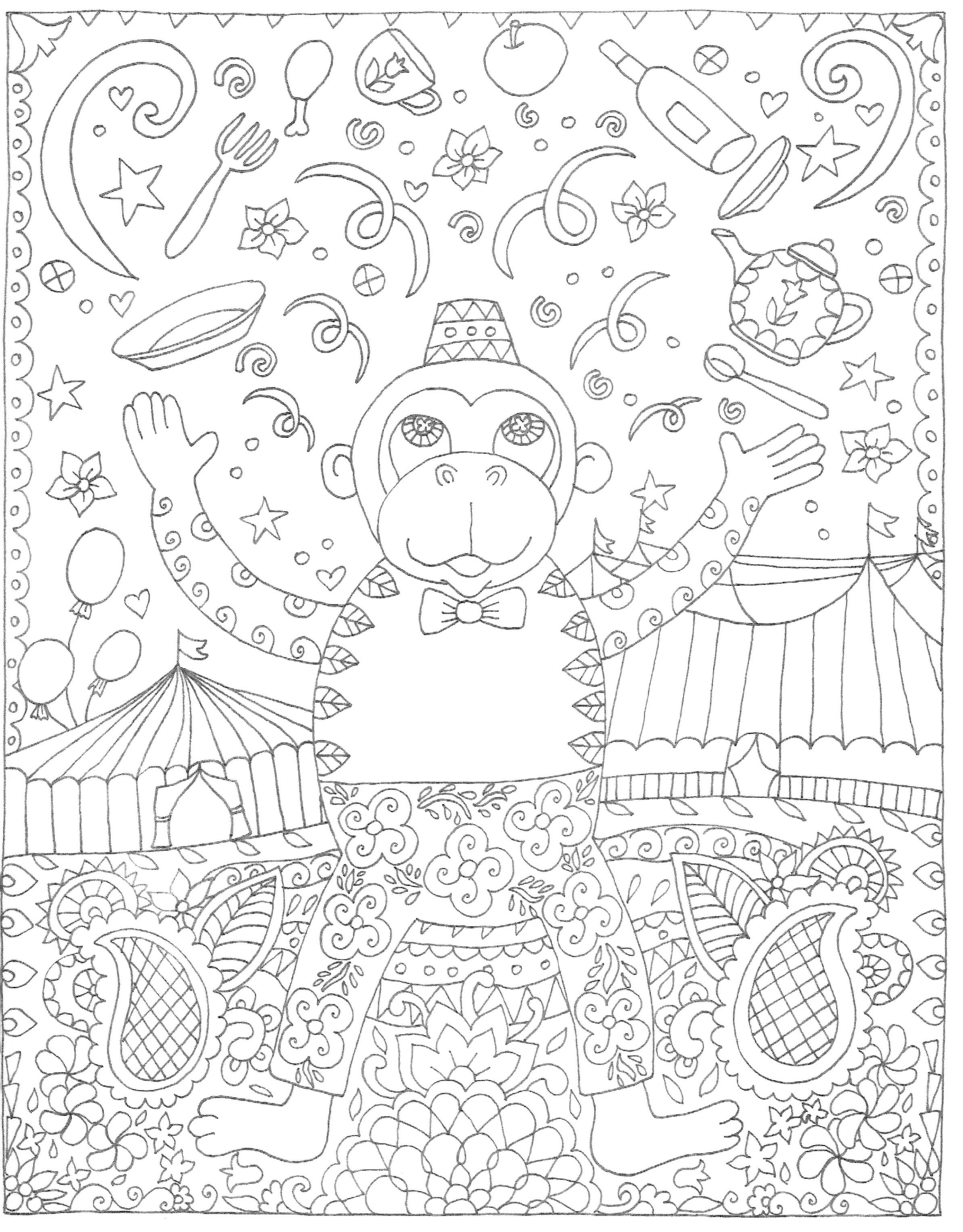

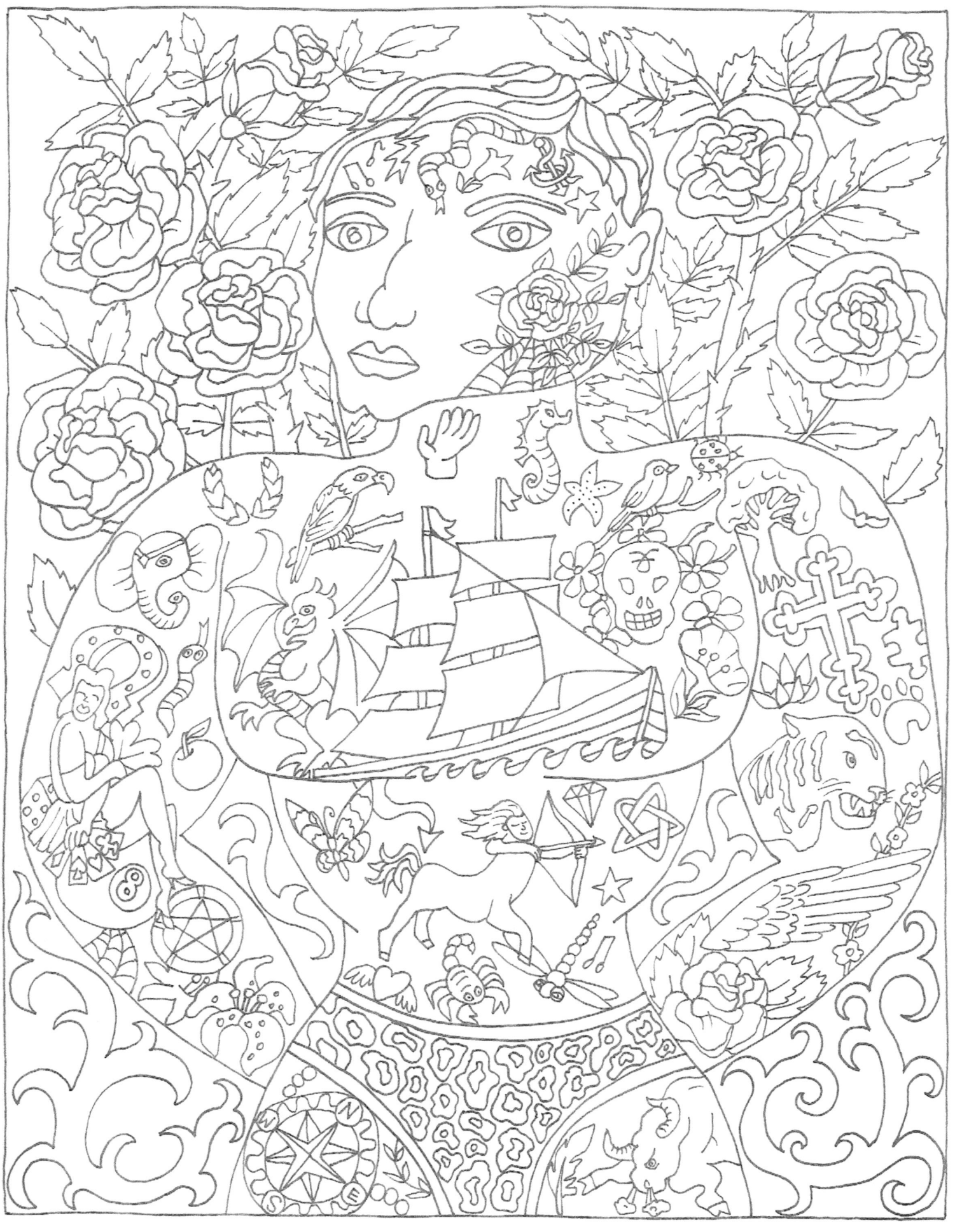

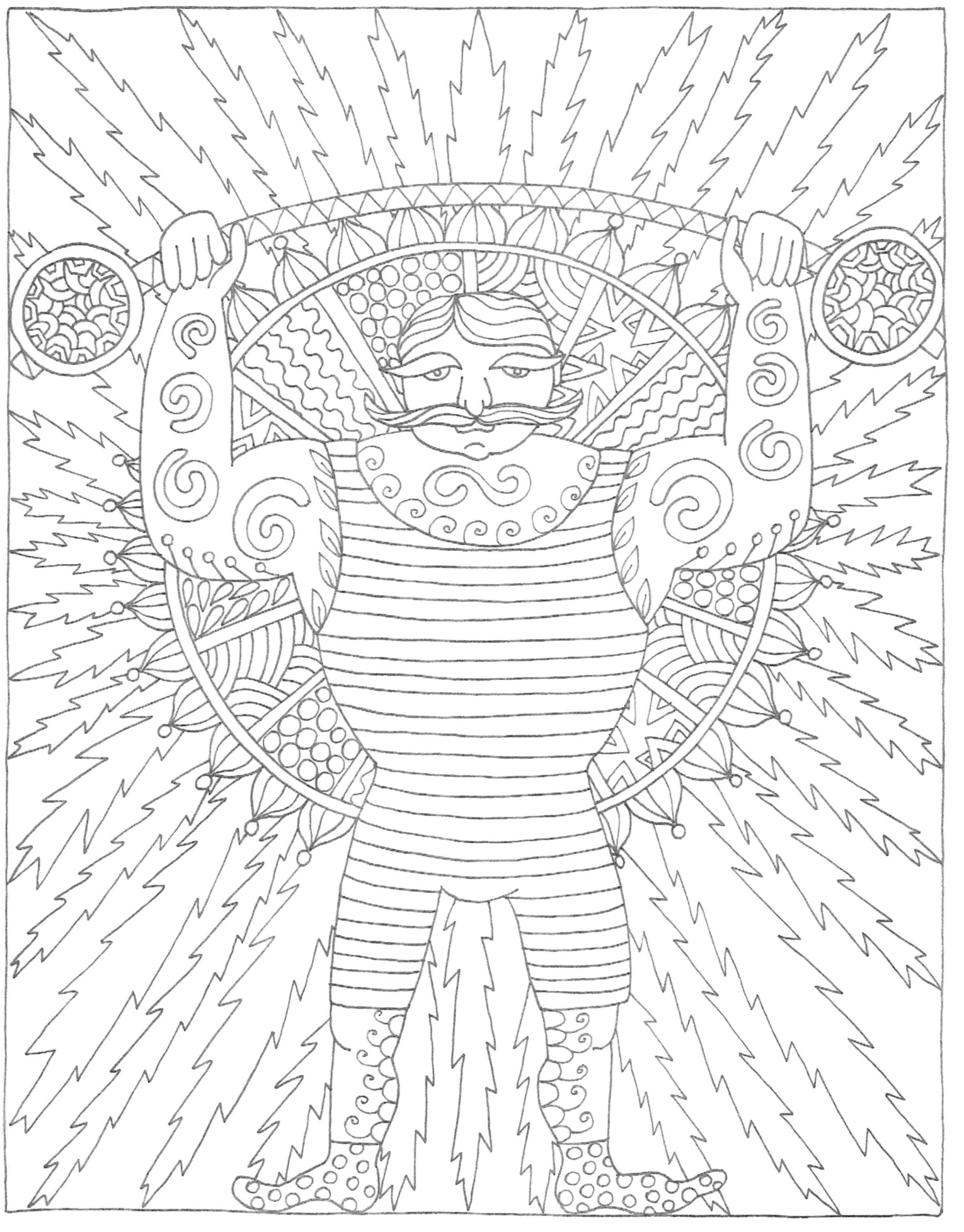

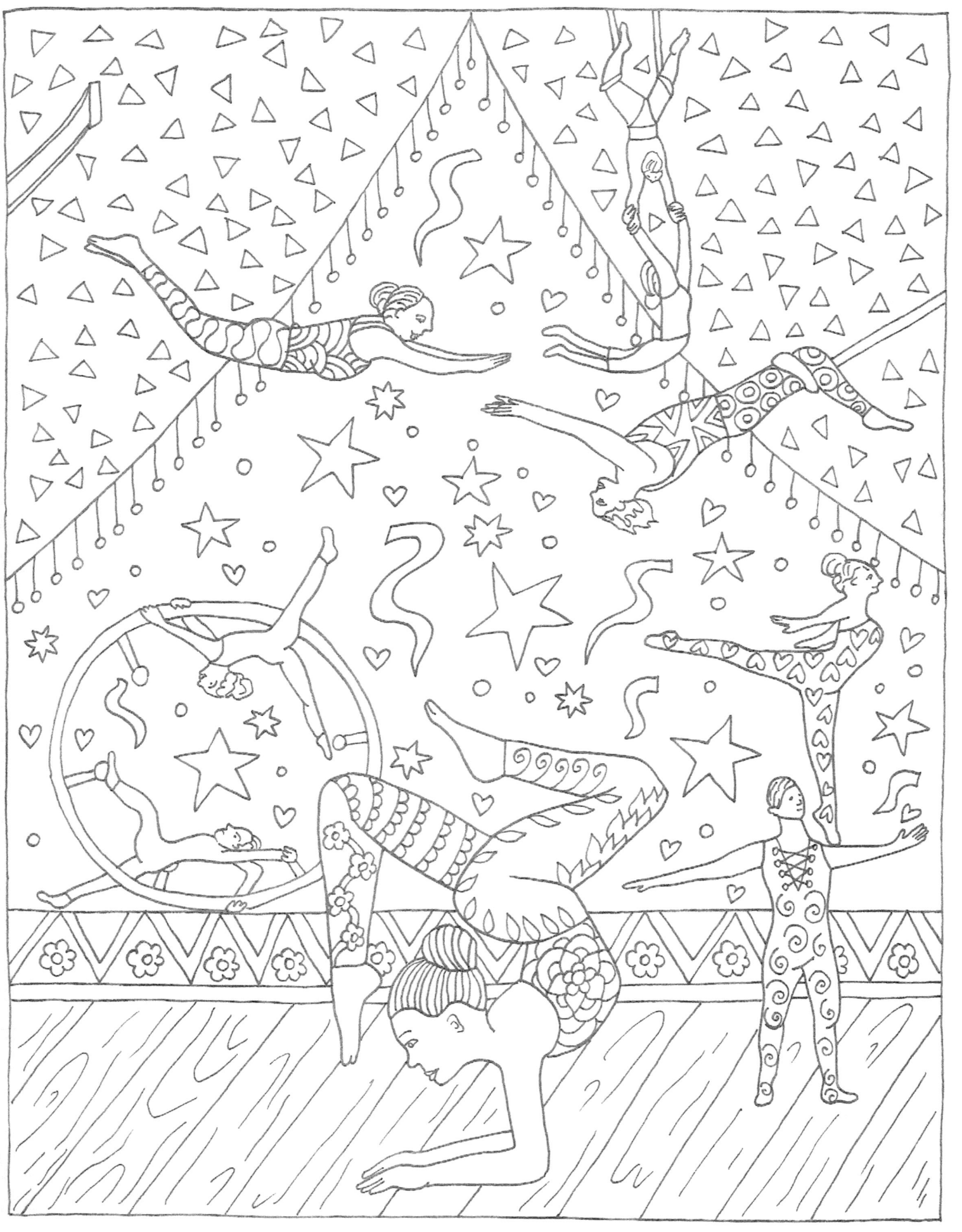

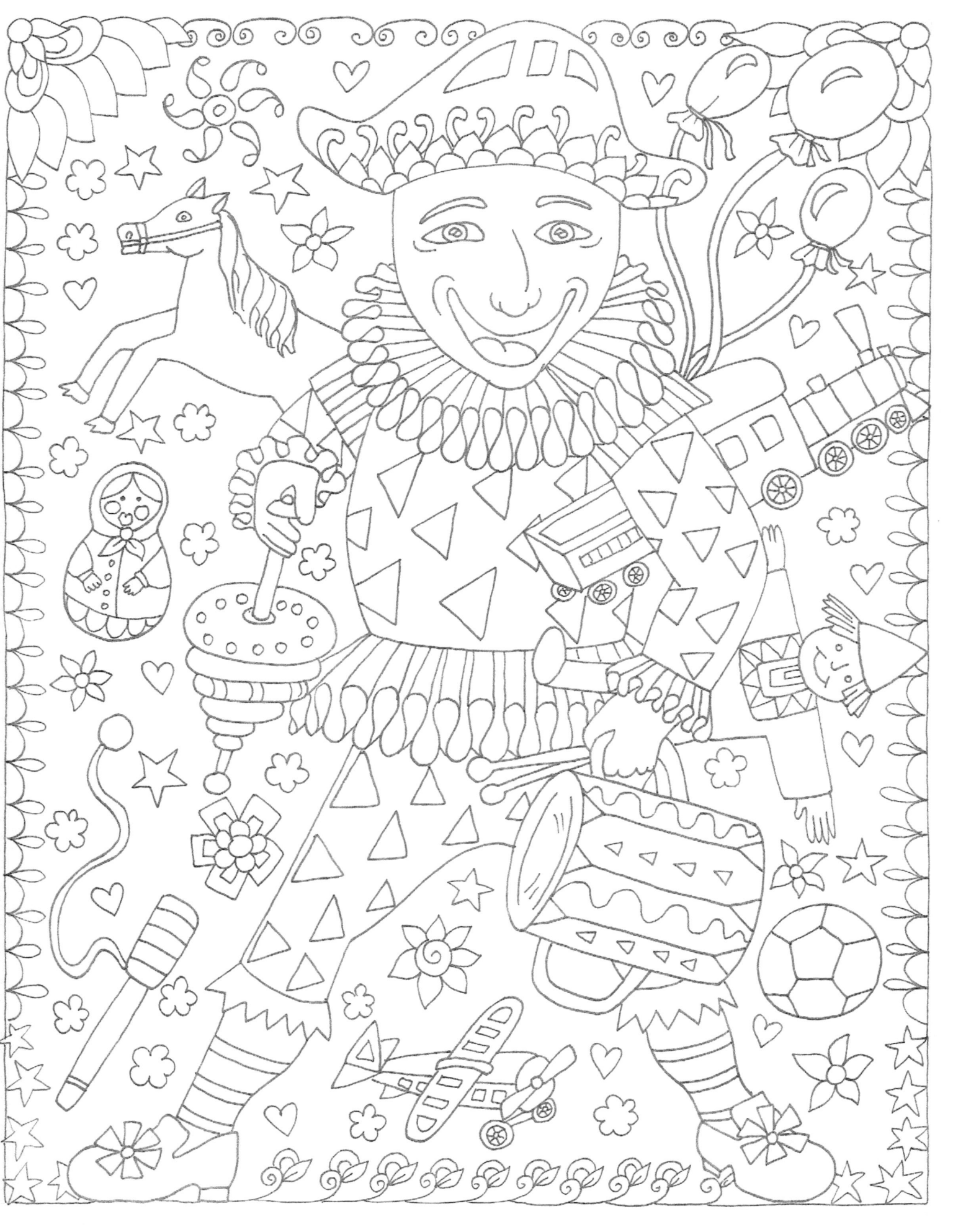

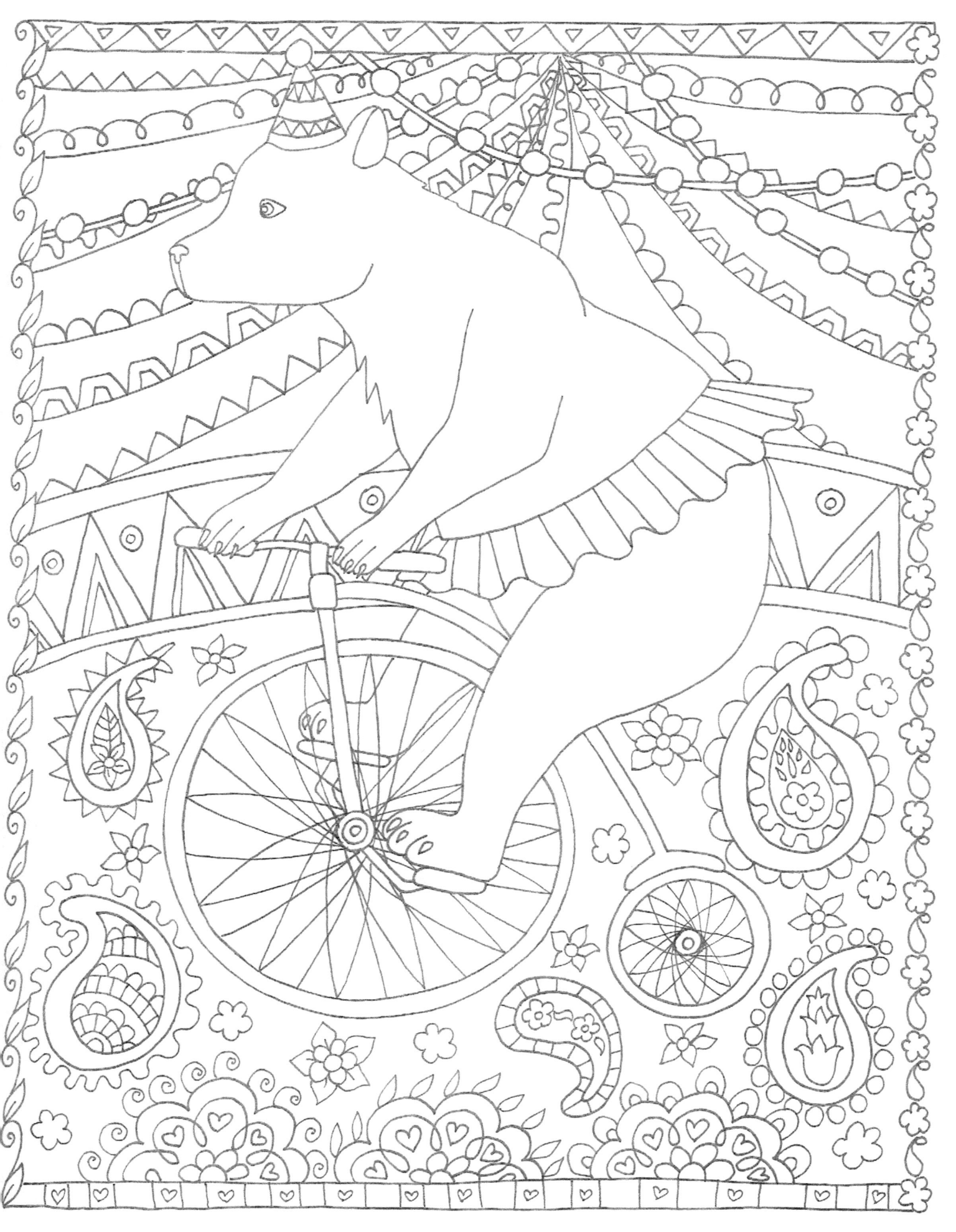

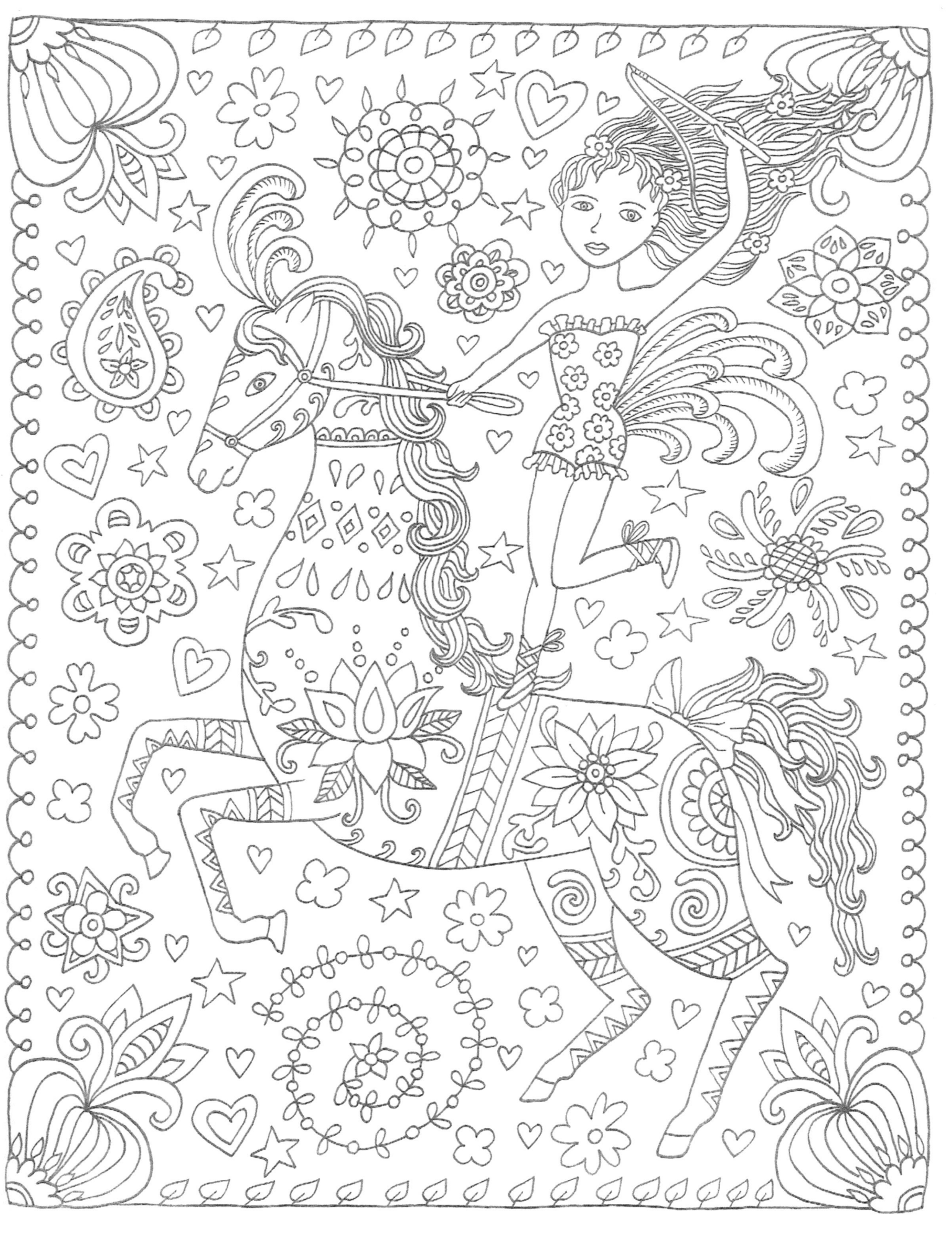

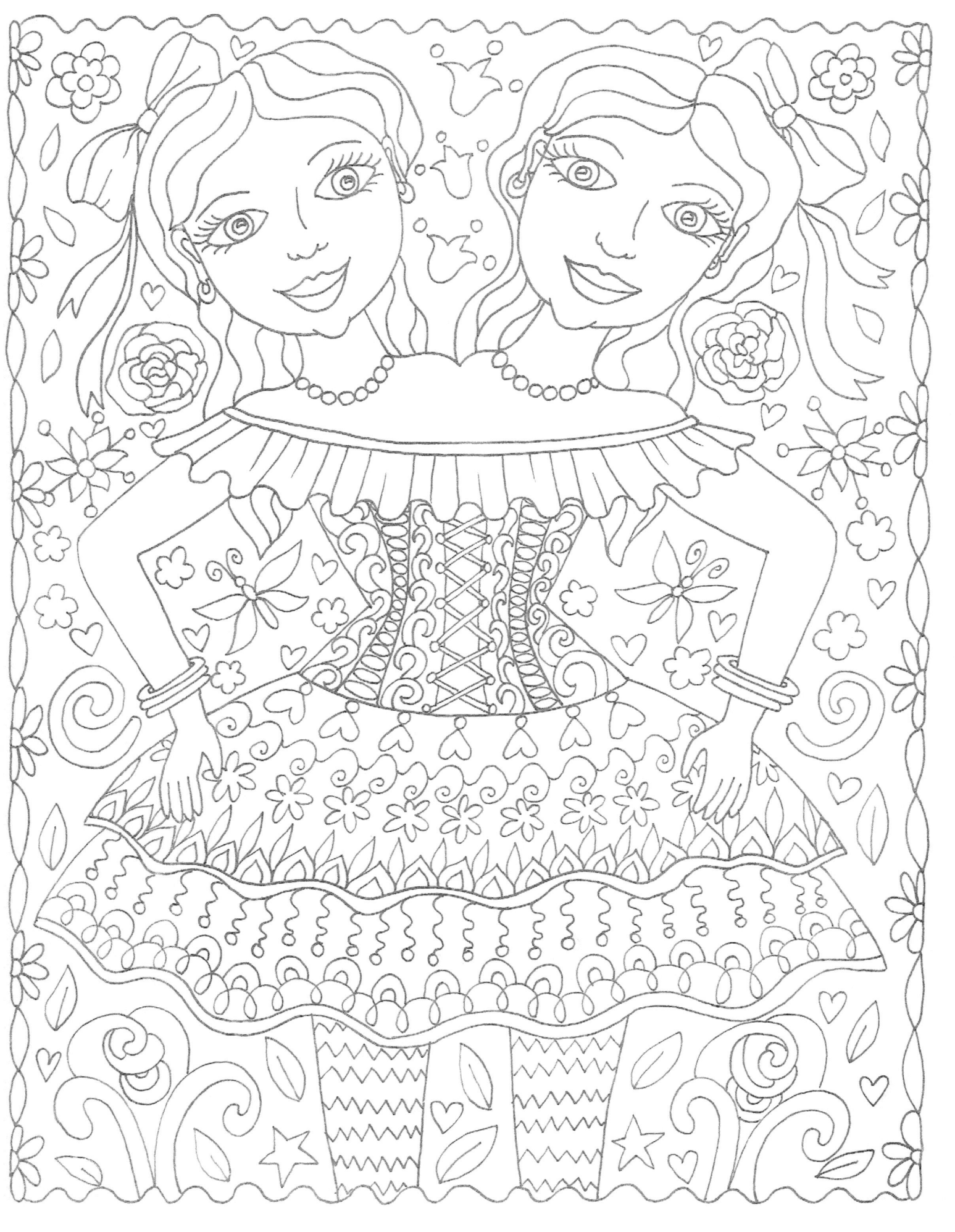

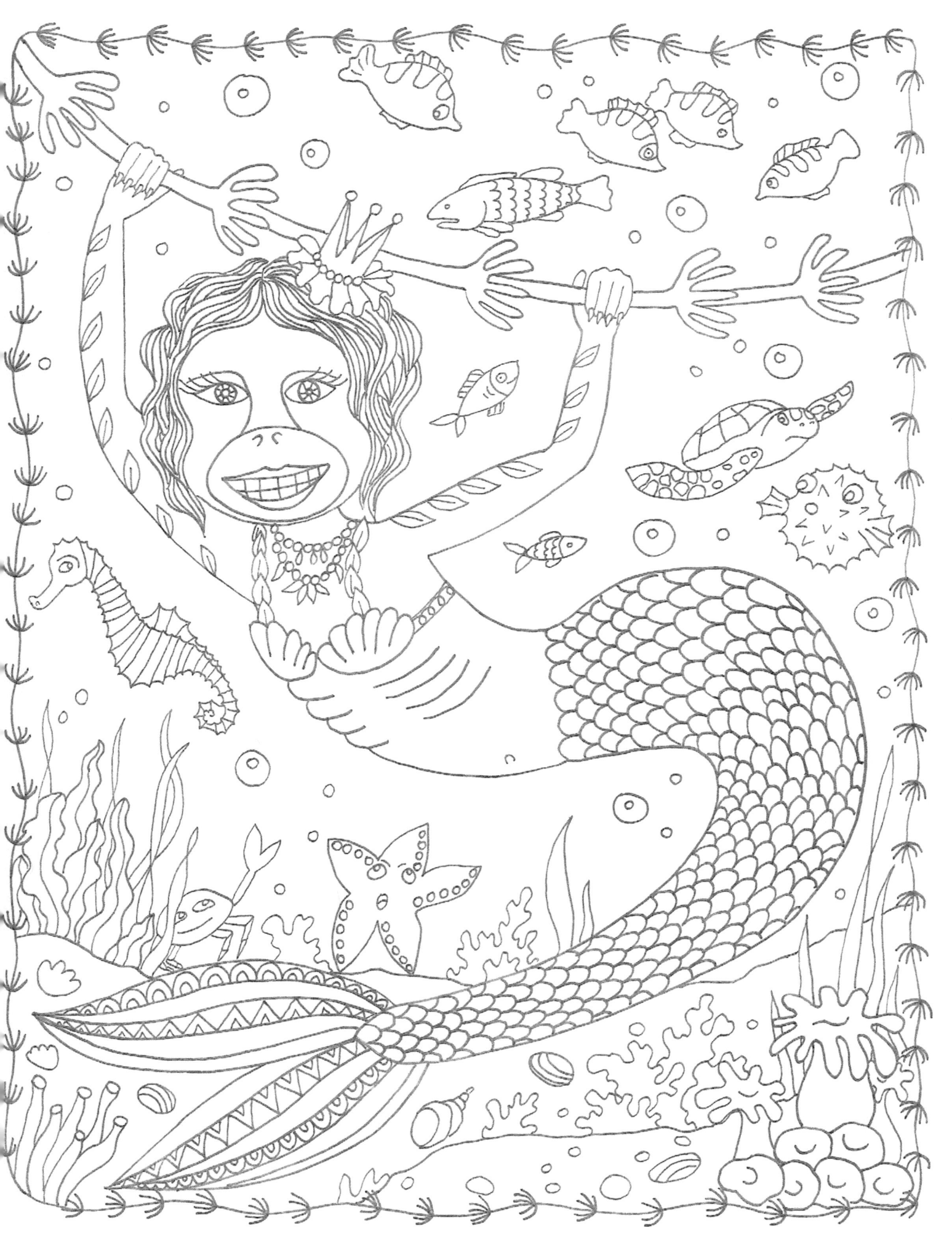

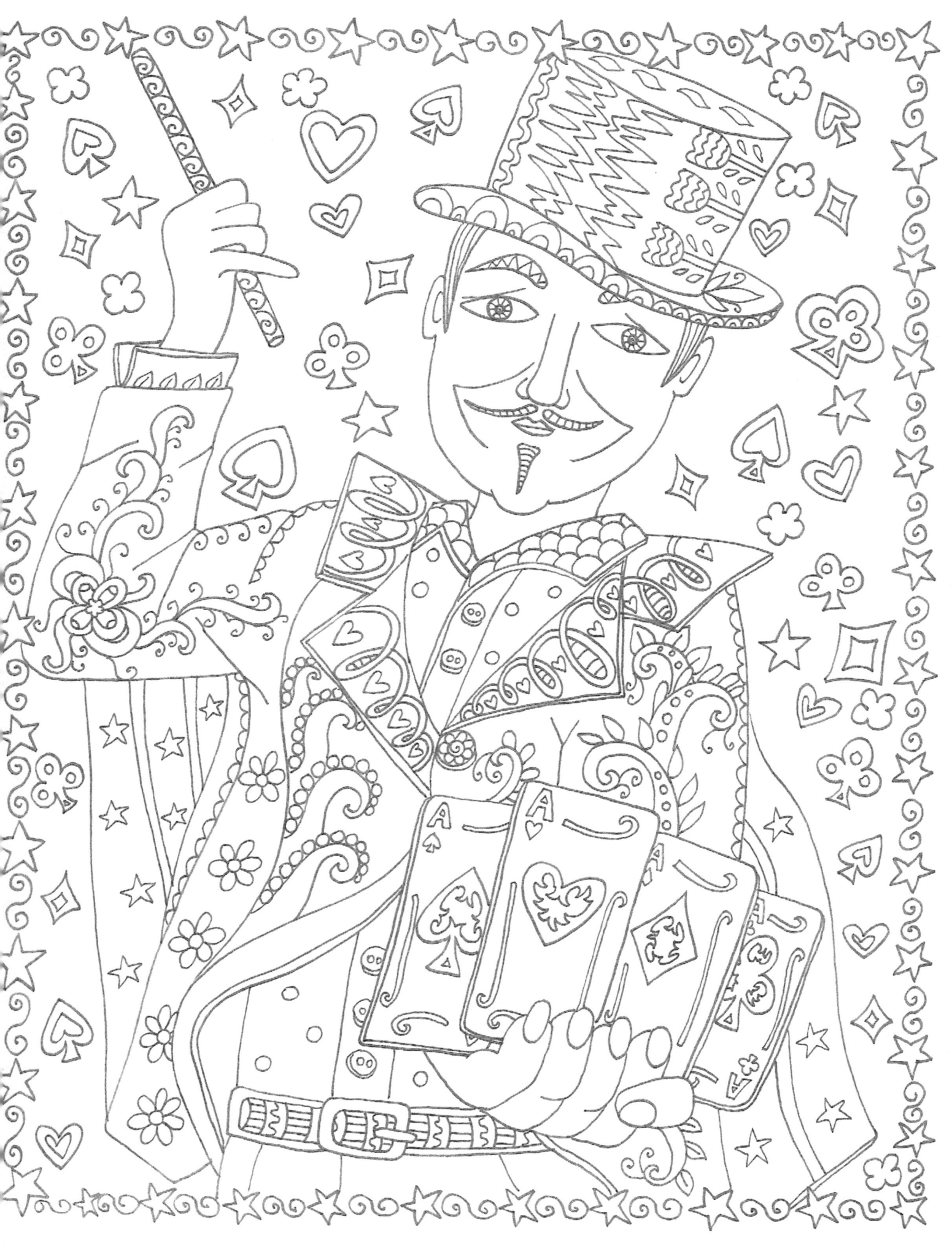

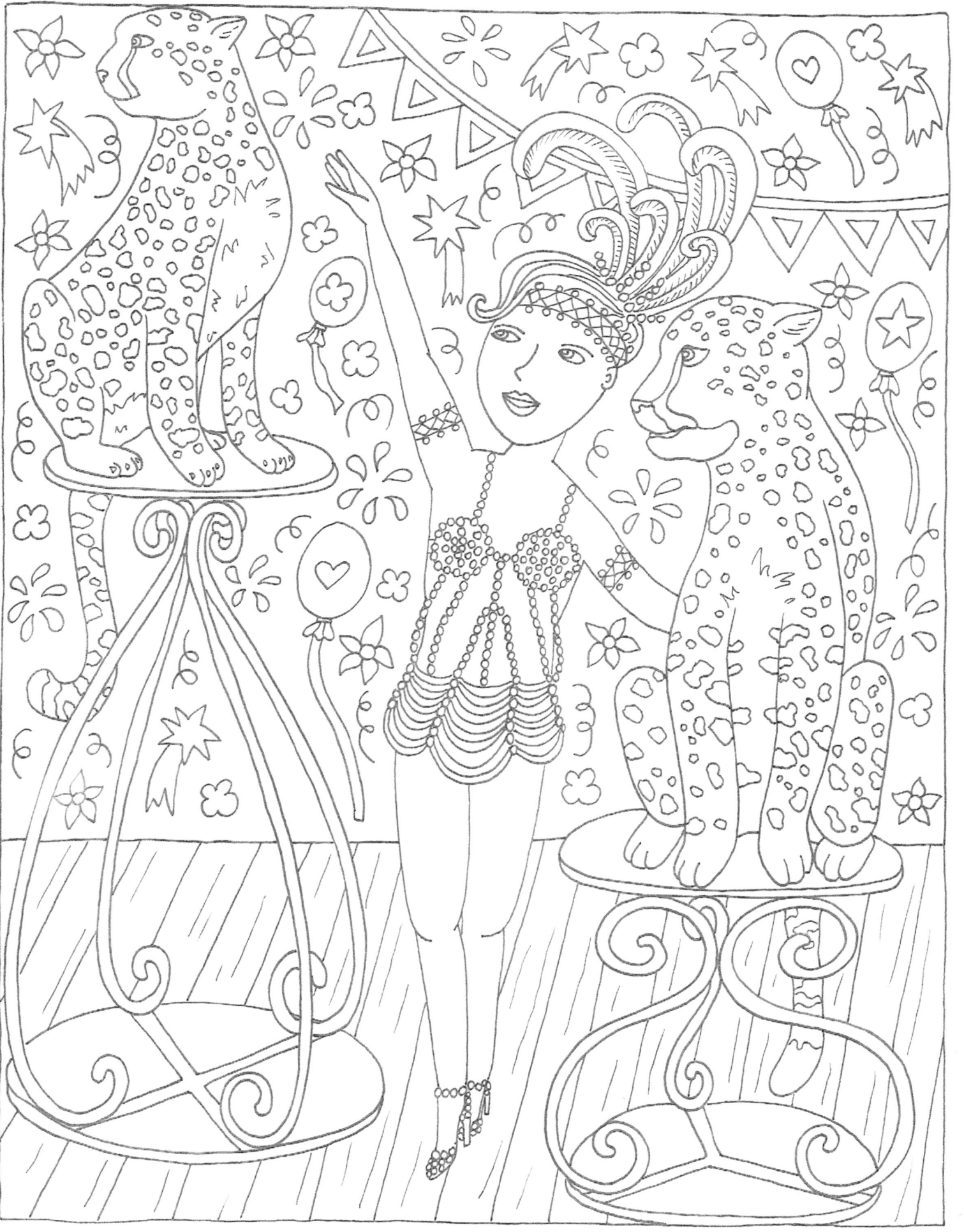

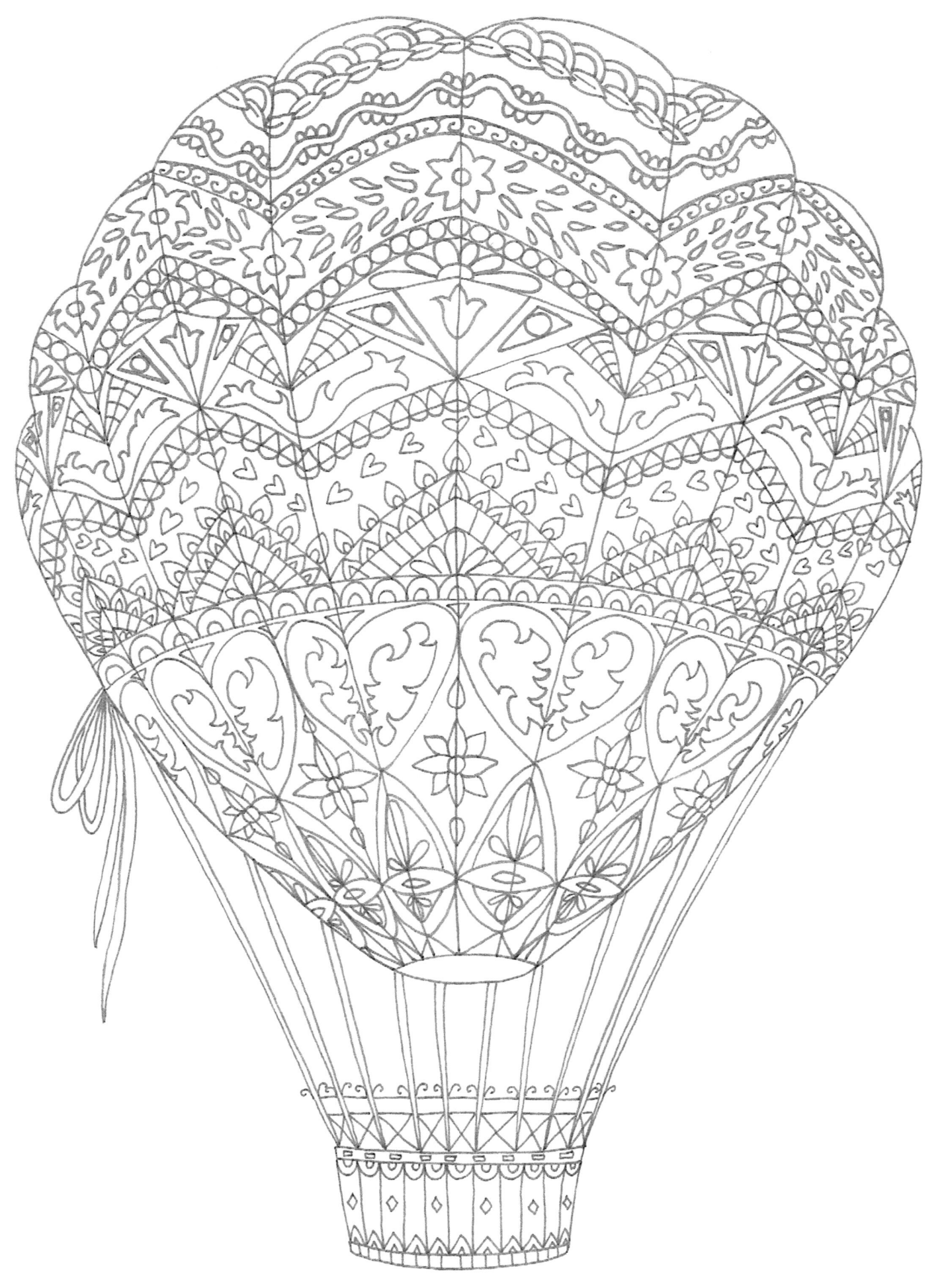

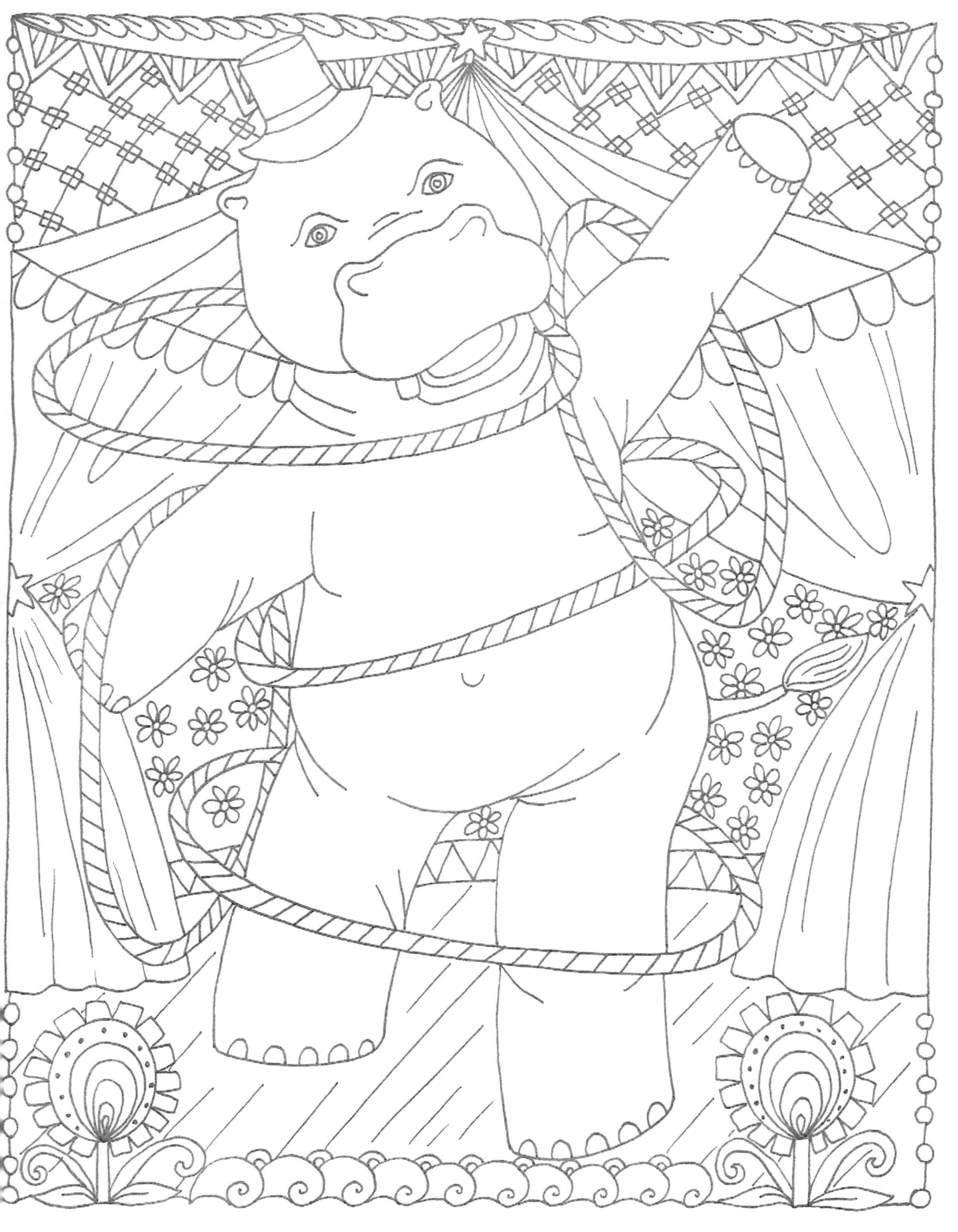

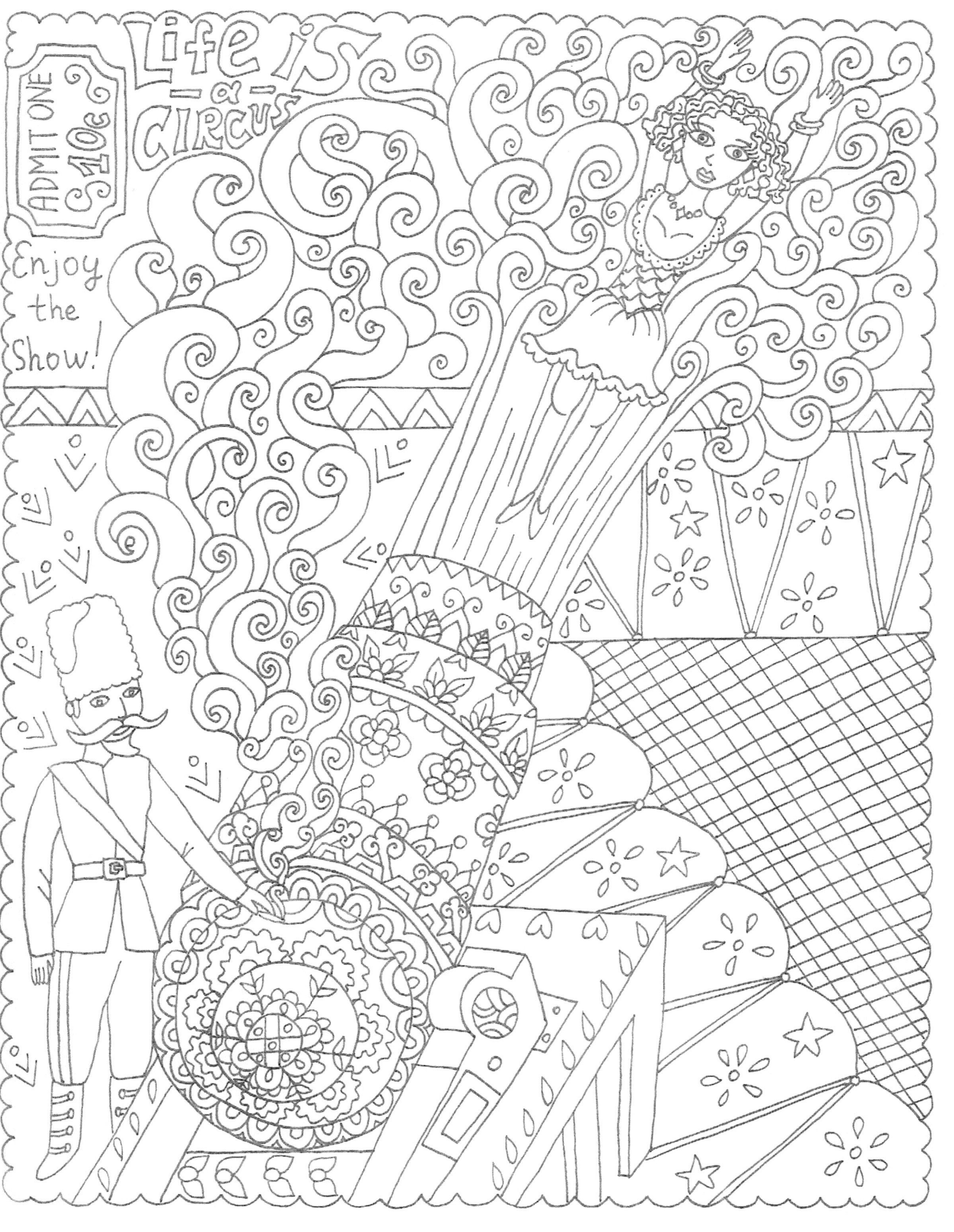

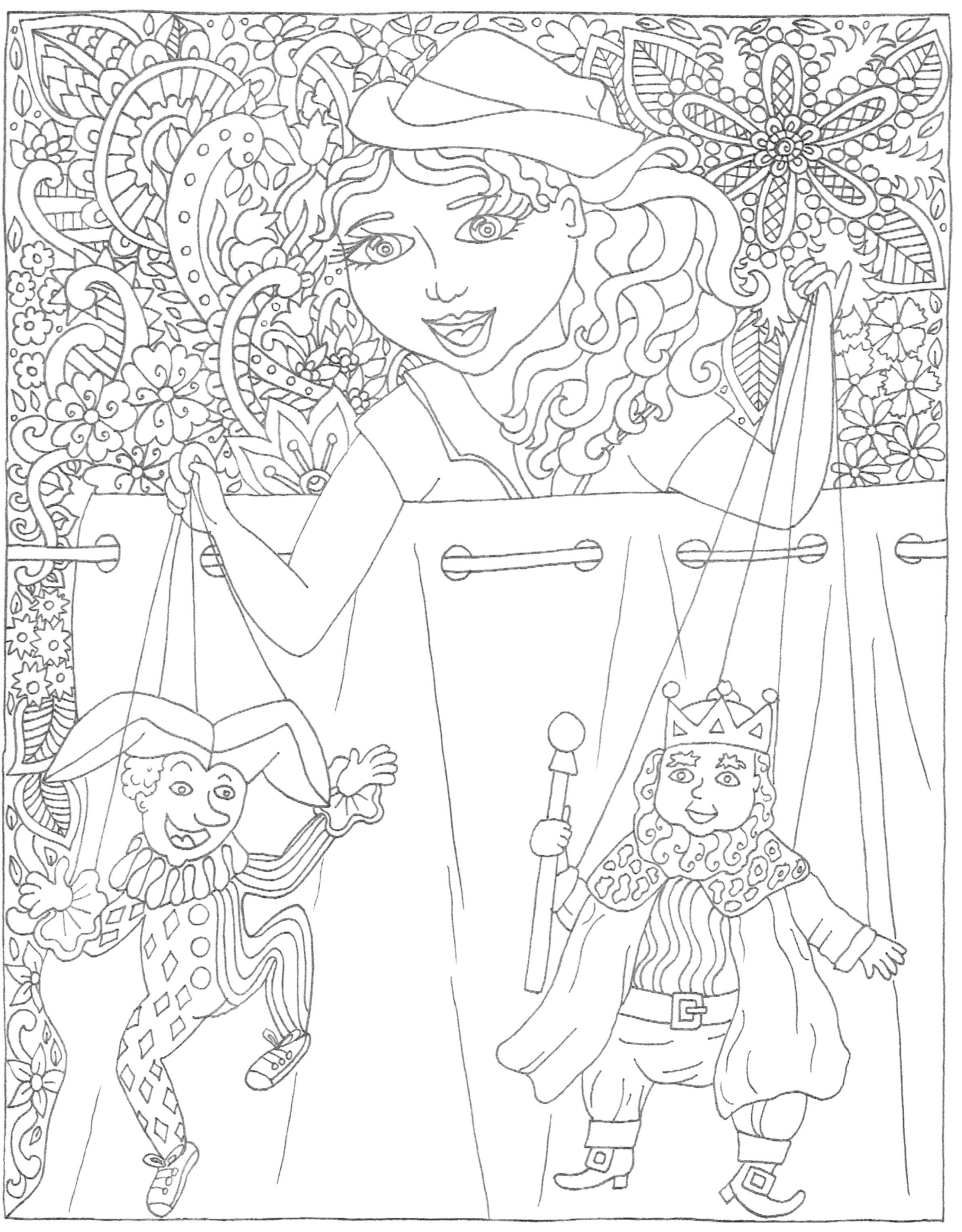

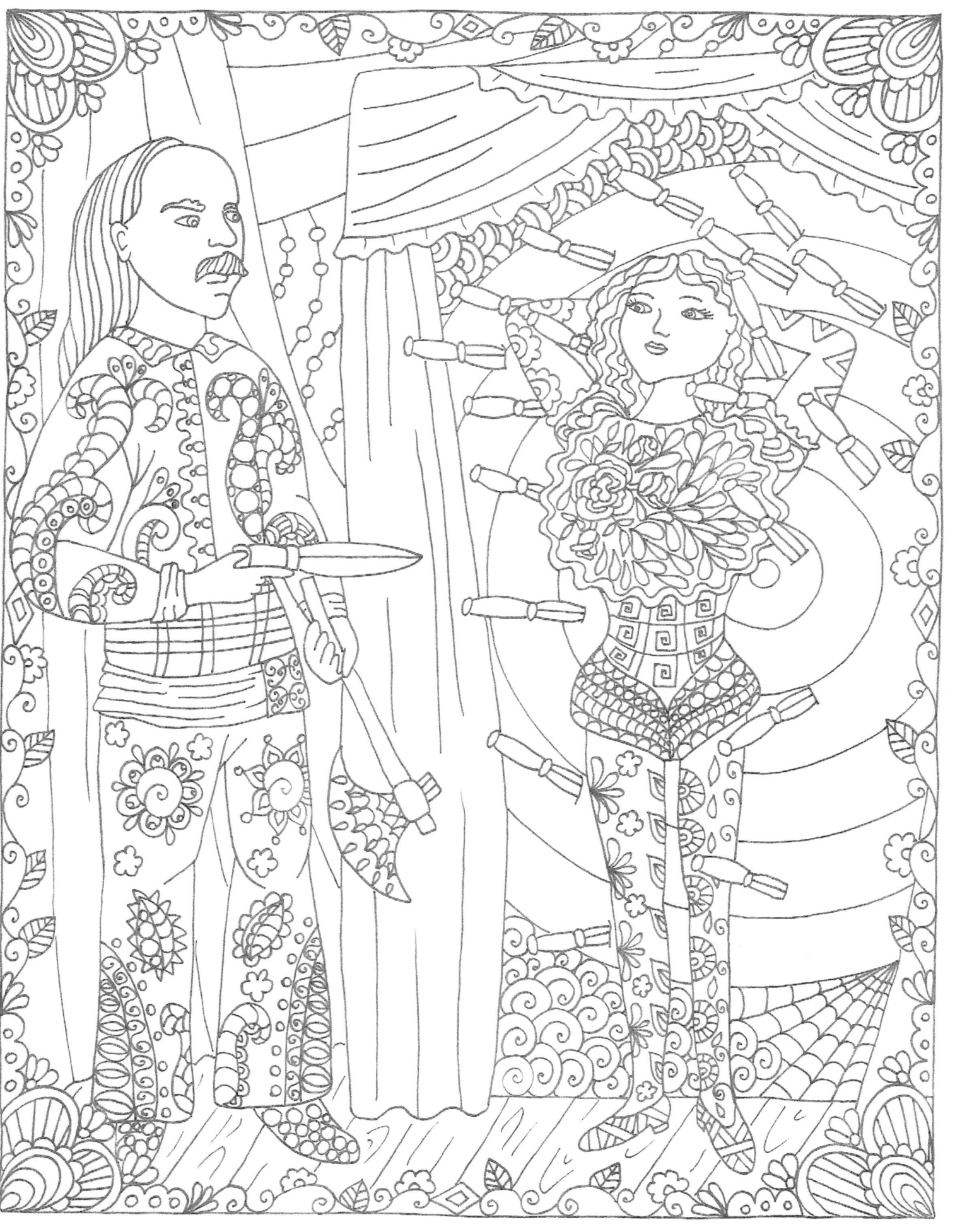

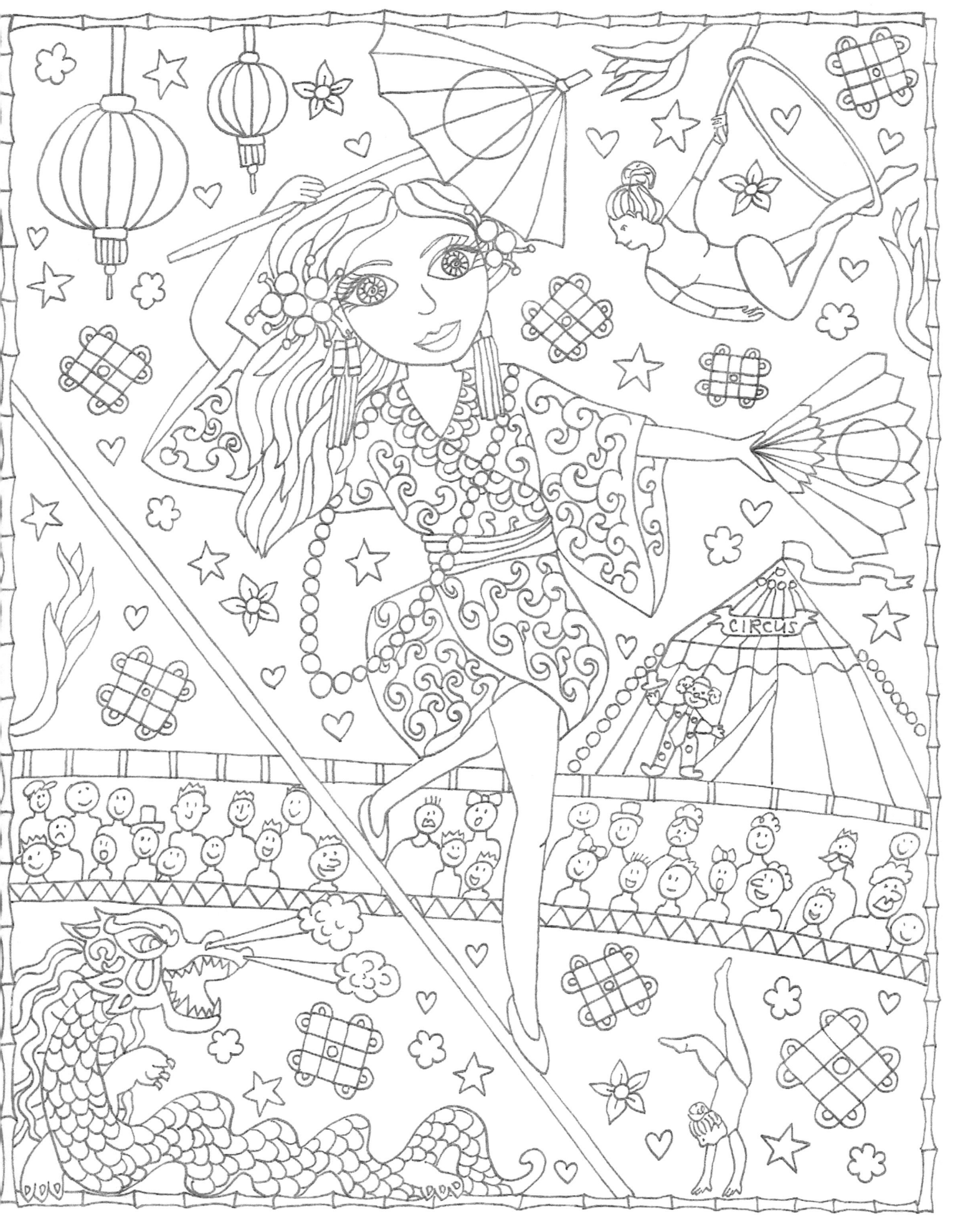

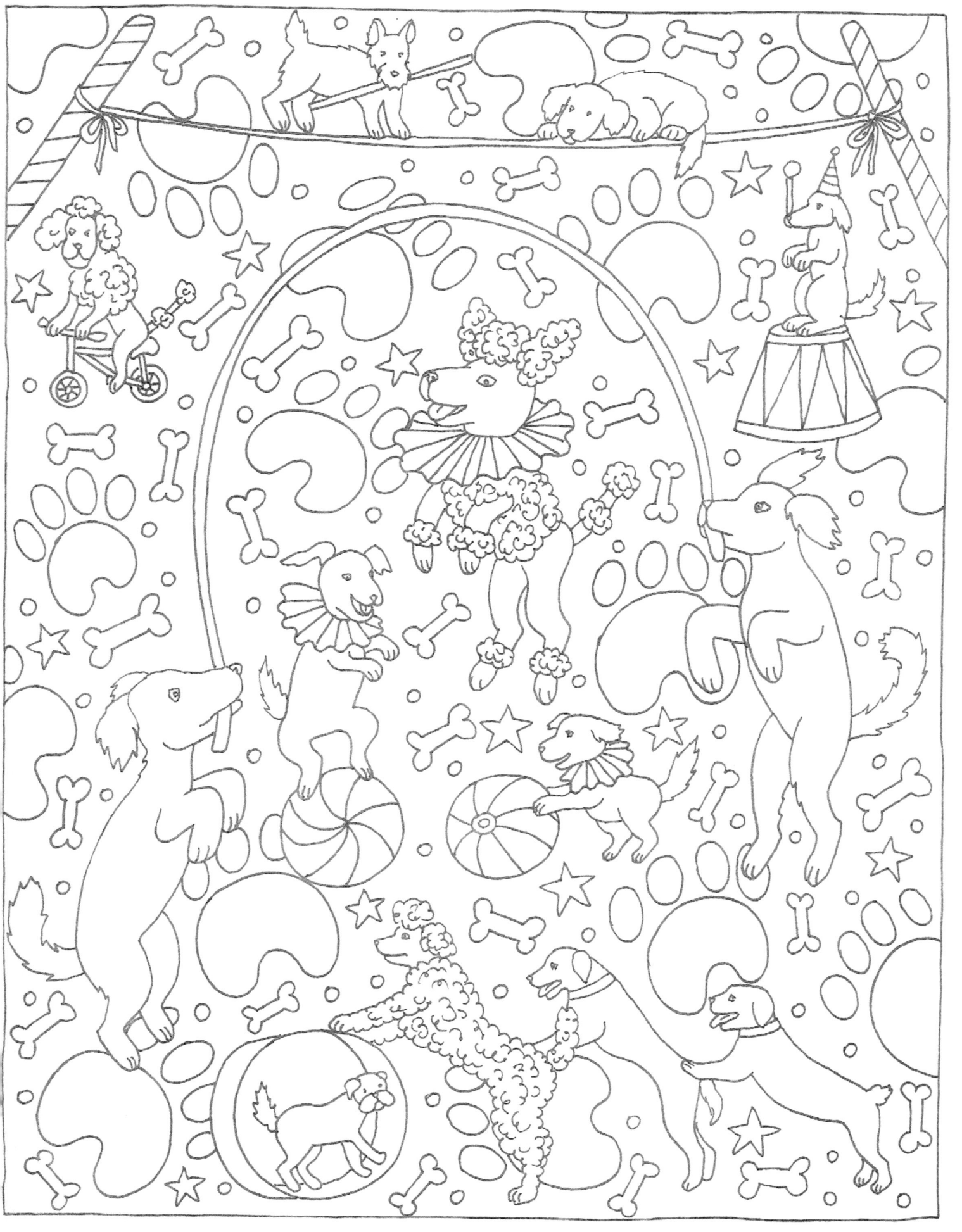

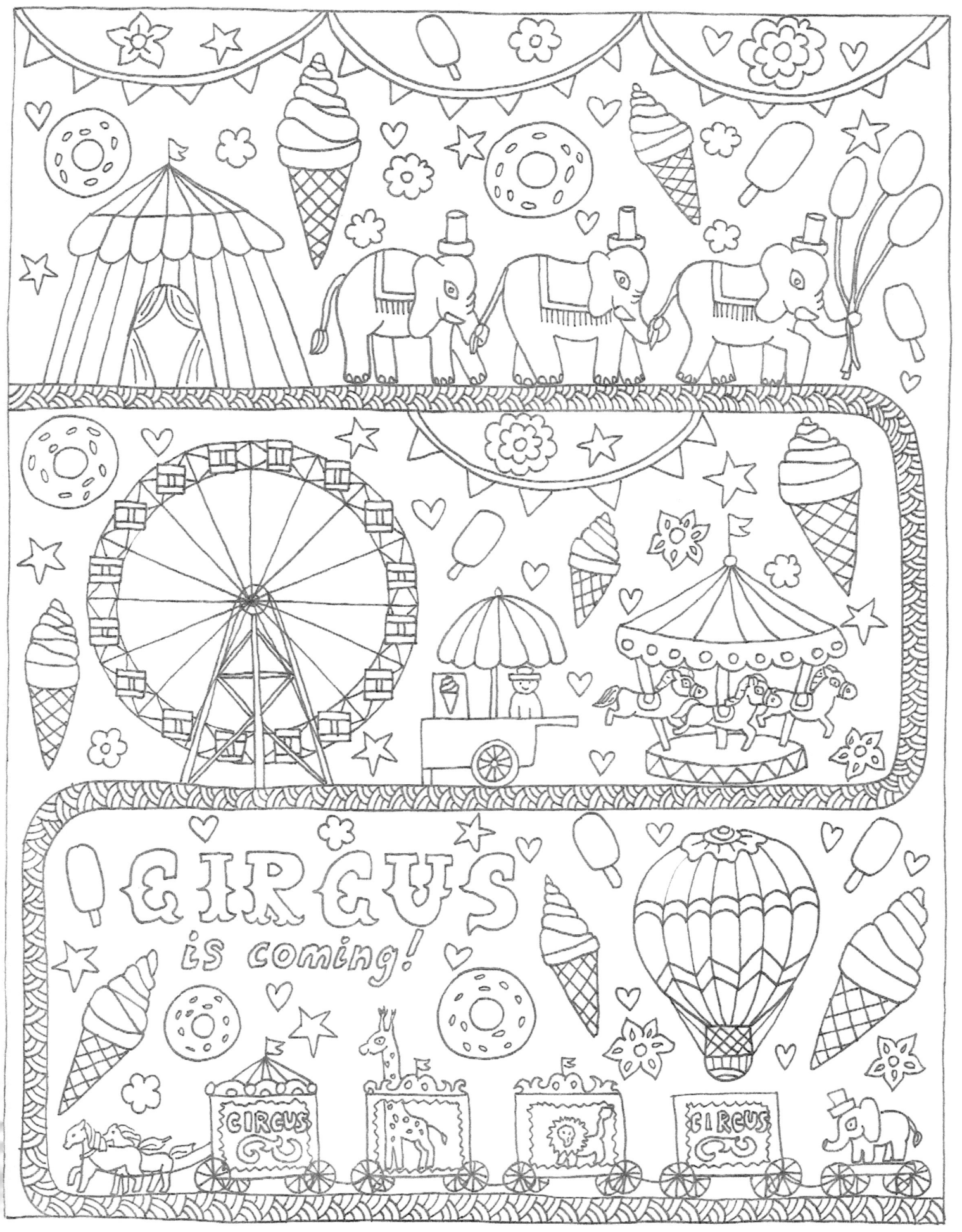

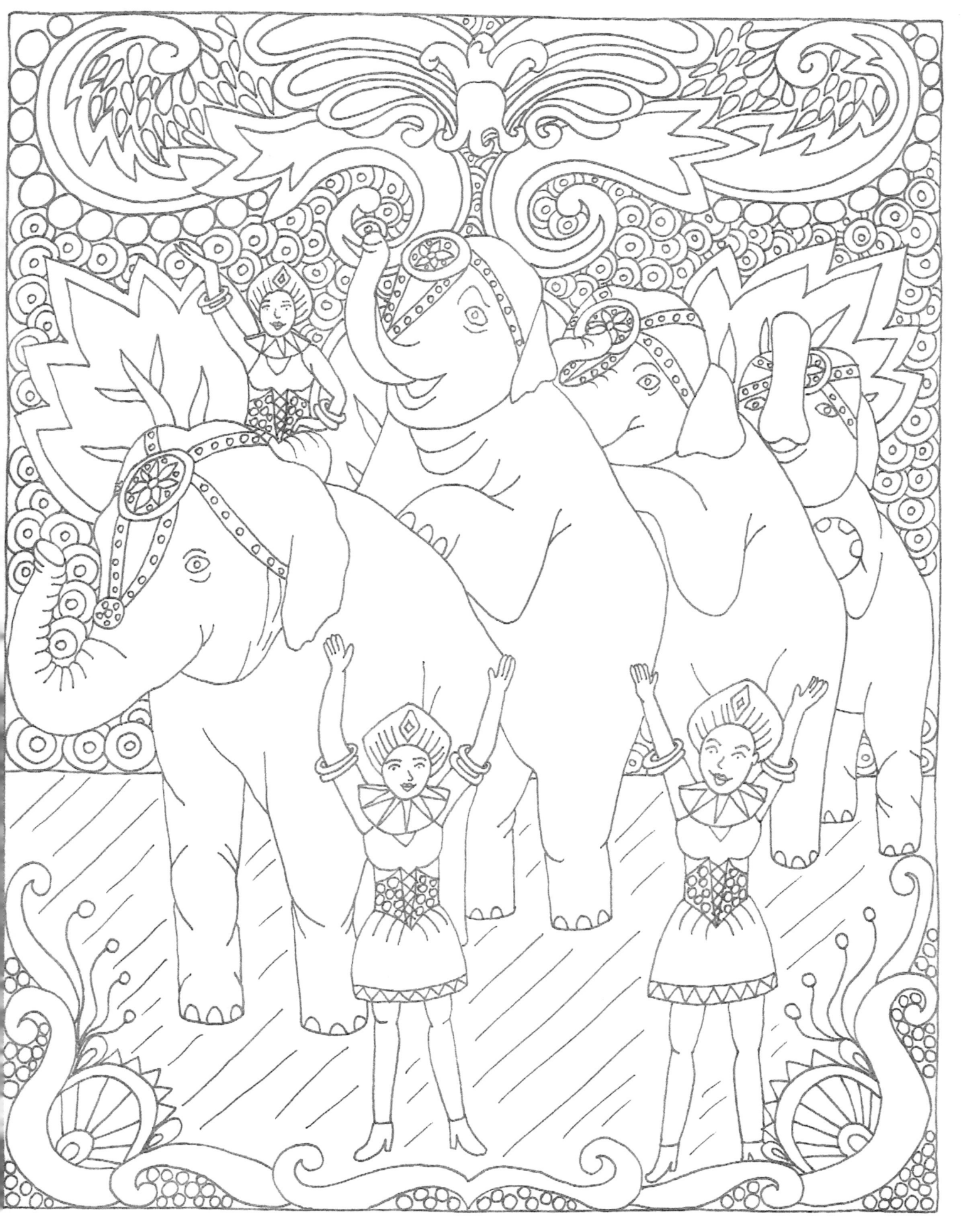

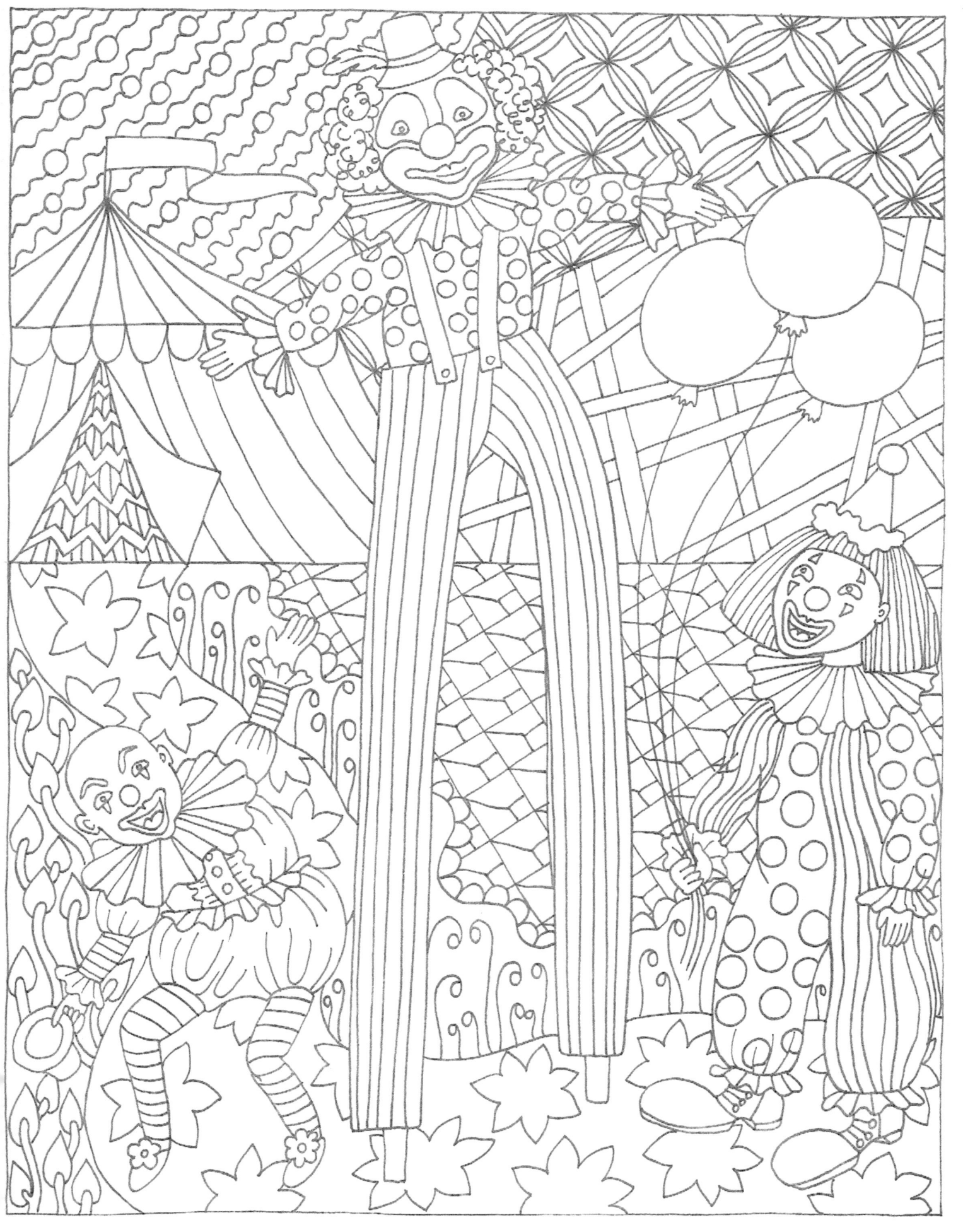

www.ingramcontent.com/pod-product-compliance
Lightning Source LLC
Chambersburg PA
CBHW080556190526
45169CB00007B/2799